Nicholas Hilliard

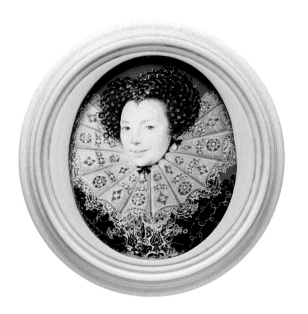

NICHOLAS HILLIARD

Karen Hearn

UNICORN PRESS LONDON

For my brother Andrew

Acknowledgement and thanks are due to
M.P. Ethelston for his financial assistance with this publication.

COVER *Self-portrait,* 1577, 41 mm diameter, watercolour on vellum stuck to pasteboard
V&A Images, Victoria and Albert Museum, London (P.155–1910)
FRONTISPIECE *Unknown Lady,* 1585–90 (in ivory box), oval 46 x 39 mm, watercolour on
vellum stuck to playing card. V&A Images, Victoria and Albert Museum, London (P.2–1974)

Unicorn Press, 76 Great Suffolk Street, London SE1 0BL
email: unicornpress@btinternet.com
Text Copyright © 2005 Karen Hearn
Illustrations Copyright © 2005 the Copyright holders as individually acknowledged

First published by Unicorn Press 2005

General Editor Christopher Lloyd

ISBN 0 906290 82 1

Designed by Gillian Greenwood
Printed and bound in Slovenia for Compass Press Limited

Contents

Foreword

In preparing this book on miniatures I do feel that (in the words of St John of Salisbury, and subsequent others) I have, paradoxically, been standing 'on the shoulders of giants'. Over the years, the remarkable work of Noel Blakiston, Torben Colding, Katherine Coombs, Mary Edmond, John Murdoch, Jim Murrell, Graham Reynolds (particularly), Sir Roy Strong, Carl Winter and others has immeasurably extended knowledge of Nicholas Hilliard's life and work, while the excellent biography by Erna Auerbach published in 1961 is a considerable achievement that has only in certain areas been superseded by later findings. I have drawn extensively on many of their insights and discoveries.

In carrying out my own research I am indebted to the great generosity – in terms both of time and of information – of Derek Adlam, Martin Allen, Helen Carron, Katherine Coombs, Alan Derbyshire, Alexandra Fennell, Nicholas Frayling, Christopher Lloyd, Catharine MacLeod, Paul Petzold and David Scrase. I am also very grateful to Hugh Tempest-Radford and Chloë Lambourne at Unicorn Press.

Finally, I would simply observe that it seems impossible to remain immune to the charm and charisma of the works of Nicholas Hilliard – and indeed that of the man himself.

Karen Hearn
London, September 2004

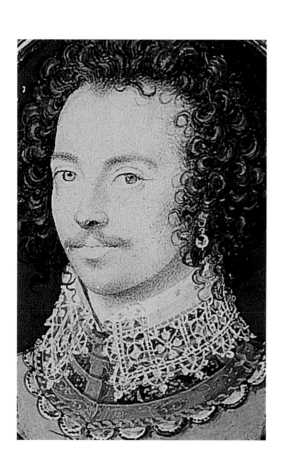

The portrait miniature

The European tradition of manuscript illumination had long included portrait likenesses, sometimes in the form of small individual heads in circular form. The portrait miniature as an independent object – detached from a manuscript page – seems first, however, to have emerged in the early 1520s, appearing almost simultaneously in France and England. In France it was seen in the work of a Netherlandish painter to the French court, Jean Clouet (1485/90–1541), and in England in a group of small early images of Henry VIII and members of his family that have plausibly been attributed to the Netherlander Lucas Horenbout (c.1490/5–1544). The children of the Ghent manuscript illuminator Gerard Horenbout, Lucas and his artist sister Susanna were active in England from the 1520s. Eighty years later the Dutch artist and author Karel van Mander was to state that it was Lucas, in England, who taught the celebrated German artist Hans Holbein II (1497/8–1543) how to paint portrait miniatures.

The sixteenth-century term for this process was 'limning', a term that appears in the title given to the treatise that Nicholas Hilliard was to write on the subject. The resultant works were known as 'limnings'. By the end of Hilliard's life, they might also, less precisely, be called paintings 'in little', distinguishing them from easel paintings 'in large'. An artist who painted them was generally called a 'limner' (although contemporaries could also sometimes use this term loosely for painters who worked on any scale).

1

The word in use today – 'miniature' – derives from the late Latin verb *miniare*, meaning to ornament a manuscript with red lead pigment, which was called 'minium'. Thus, it originally had nothing whatever to do with smallness of size.

The basic process used both by Lucas Horenbout in England, and the Clouet family in France, was to apply pigments in a water-based medium to a small piece of very fine vellum which had already been stuck on to a piece of pasteboard, usually a playing card (and thus sometimes still bearing heart, club, diamond or spade symbols on the back). The painting would be completed and subsequently cut out. Although we do not know how or when he learned it, this is the process that Hilliard followed. The techniques required are wholly different from those of painting 'in large' – on wooden panel or the newly introduced linen canvas – although there is evidence that Hilliard occasionally did this, too.

Portrait miniatures are delicate, fragile objects. In the space of more than four hundred years many of Hilliard's works have, in varying degrees, become faded through exposure to light, or cockled through being subjected to damp conditions. The paint has often flaked, particularly where thickly applied, and – as a result – some of his works have undergone heavy-handed 'restoration'. The inscriptions, too, may have been altered or even removed. A particular problem can be tarnishing, through oxidation, of the silver paint that Hilliard particularly favoured, which means that the images no longer literally sparkle in the way that they originally did.

In many cases, moreover, the identities of the miniatures' subjects have been lost. This book focuses as much as possible on images of known sitters but, even so, there are numerous surviving examples that can now, tantalisingly, only be given the title *Unknown Lady* or *Unknown Gentleman*. It is clear that only a proportion of Hilliard's total output has survived. We have no way of knowing how many more pictures have been lost to time, decay or destruction.

Nicholas Hilliard in his time

The painted works of Nicholas Hilliard open a remarkable window on to the highest levels of British (particularly English) society in the later years of the sixteenth and early years of the seventeenth century – the Elizabethan and Jacobean ages. His images show us the features of many of the key figures of his time – with a comparative naturalism that is usually absent from the contemporary large-scale paintings that were executed by other artists. Hilliard's representations have helped to form our ideas of the appearance of, for instance, Elizabeth I, Mary Queen of Scots, Sir Walter Ralegh, Sir Francis Drake, James I, and Robert Dudley, 1st Earl of Leicester.

At the same time, Hilliard's miniatures do show characteristics also found in the large-scale portraits of the period. Pieces of text are included with the image, the words contributing significantly to the message of

the portrait. All the early miniatures and most of the mid-century paintings have a plain background; from the evidence of those that survive, it appears that the representation of a figure within a specific setting (sometimes seen on larger paintings earlier in the sixteenth century) came back into fashion in the 1580s – probably first in miniatures, and with Hilliard leading the way.

In sixteenth-century portraiture, details of costume are paramount. Status and wealth are, for instance, conveyed through the depiction of a sitter's jewellery as well as rich and decorated fabrics. Both Hilliard and the large-scale painters faithfully record these. Yet, alongside the jewellery, sitters are also adorned with individual fresh flowers or sprigs of greenery – symbolic elements whose meaning may today have largely become lost (see, for example, illustrations 9 and 27).

Born in the West Country at around the time of Henry VIII's death in 1547, Hilliard's early travels in western Europe gave him a significantly international outlook (initially at least) that enabled him to offer his clients between the 1570s and the 1590s a compellingly attractive product.

For most of the artists who worked in England during the sixteenth century, very little biographical information usually survives. We seldom know what an artist actually looked like, nor do we generally possess any document that gives us an insight into their professional attitudes and prejudices and their working practices.

Nicholas Hilliard is an exception. Although much about his long life is still unclear, the scrupulous study of a wide range of documents by

various scholars, particularly Erna Auerbach and Mary Edmond, has allowed a basic outline of his life to be reconstructed. Hilliard's dashing self-portrait miniature – the cover image to this book – survives (with some old damages round the edge) in the Victoria and Albert Museum, London. Above all, his manuscript' A Treatise Concerning the Arte of Limning', written around 1600, reveals his own idiosyncratic thoughts on the field in which he worked, as well as his account of some of the techniques that he employed.

The treatise

Hilliard's treatise is justly described as one of the most important documents in the history of British art. A manuscript copy survives in Edinburgh University Library (MS Laing III 174). This is not in Hilliard's own hand, but in that of an unknown individual – probably, to judge from the nature of the 'secretary hand' script, that of a professional scribe. It is dated 1624 – that is, five years after Hilliard's death – and seems to be a draft rather than a fully finished account. Its opening is missing and it appears to break off before its intended conclusion. In the manuscript, Hilliard's own text is followed by another, separate, text on art techniques by Edward Norgate (?1580/1–1650), the 'More Compendious Discourse'.

Hilliard probably drafted his treatise at the request of the doctor and art enthusiast Richard Haydocke, a Fellow of New College, Oxford. In

1598 Haydocke had published an English translation of G.P.Lomazzo's *Trattato dell' arte della pittura, scoltura et architettura*. In his introduction to this, Haydocke, likening the work of Hilliard – which was 'so much admired amongst strangers [that is, abroad]' – to that of the celebrated Italian Renaissance painter Raphael, extolled 'his perfection in ingenuous Illuminating or Limming, the perfection of Painting', which had prompted him to ask Hilliard to write an account of the subject.

As its recent editors R.K.R.Thornton and T.G.S.Cain observe, Hilliard's text has three strands. First, it is a formal explanation of the theory and status of limning that can be traced back to Lomazzo's original themes. Second, it is a practical manual on Hilliard's own methods and materials of painting – although, unusually, it also has a section on precious stones and their relationship to the colours used in his miniatures (reflecting Hilliard's training as a goldsmith). Finally, it also contains a certain amount of personal biography, which is sometimes intermingled with a thread of complaint.

In the following pages, all quotations from Hilliard's treatise are taken from the Thornton and Cain edition.

Further practical information about Hilliard's technique is also given in British Library MS Harley 6376, a seventeenth-century manuscript that contains sections by a much younger artist who had clearly received some training from Hilliard himself – or 'Old Mr Hillyard', as he terms him. It has been suggested (though by no means proved) that this could have been the painter of portrait miniatures John Hoskins (*c*.1590–1664).

Hilliard's text evidently circulated widely because sections of it are reproduced verbatim in subsequent writings by other authors. It is particularly interesting to note that a manuscript copy of the treatise was recorded in 1664 as having been in the possession of 'Mr. Garrat, Limner to Queen Elizabeth' – presumably the leading painter 'in large', Marcus Gheeraerts II (1561/2–1636), whose most celebrated sitters included Elizabeth I and James I's queen, Anne of Denmark.

Format and use

The portrait miniature is among the most sophisticated products of sixteenth- and seventeenth-century England. In an era in which large-scale portraits present a very public face – upright, unsmiling and almost exclusively focused on status, which is indicated through detailed depictions of rich fabrics, jewellery and heraldry – the miniature, in contrast, is generally small enough to be viewed while held in the hand, giving a personal, one-to-one experience. Today largely seen through the glass of museum display cases, portrait miniatures were originally housed and seen in a variety of ways. Very few remain in their original cases, the vast majority having, over the years, been repeatedly reframed in containers deemed more up to date by subsequent owners. There are many documentary references to the 'portrait boxes' in which miniatures were often kept. Occasional German or Dutch examples of such small

circular turned wooden frames, resembling boxes, survive, holding single or paired miniature images. A few sixteenth-century English portrait miniatures are still found in early turned ivory round settings (for example, illustrations 13 and 27))

Miniatures were also set as items of jewellery, such as lockets and pendants, emphasizing their function as luxury objects. Such a locket might be worn with the lid closed or, occasionally, without a lid so that the wearer could display the miniature, and thus his or her personal or political allegiance. Not only is this usage recorded in documentary accounts, it is also seen in certain large-scale portraits – such as a three-quarter-length depiction of an unknown lady, formerly identified as 'Lady Walsingham'; in this painting, dated 1572, the lady is shown carefully holding a miniature open to reveal a man's portrait (private collection, reproduced in Strong 1983, p.64, no.61). A miniature case that still survives today is shown being worn closed in a portrait of Sir Francis Drake of 1591, which is attributed to Marcus Gheeraerts II (National Maritime Museum).

Hilliard's life and career

Nicholas Hilliard is thought to have been born in 1547. His father Richard (see illustration 10) was a leading goldsmith in the city of Exeter, and of gentleman status. His mother, Laurence, née Wall, was herself a

goldsmith's daughter. This was an age of great religious and political turbulence. Richard Hilliard was a firm Protestant, and, during the brief reign of the Catholic queen Mary I, he chose for his son exile on the Continent, with the family of Exeter merchant John Bodley (whose son Thomas would, as an adult, found the Bodleian Library at Oxford University). The whole party were recorded in Germany in 1555 and in Geneva in 1557. On their return to England in 1559, following the accession of the Protestant Elizabeth I, it is thought that the young Nicholas may have resided with John Bodley in London. On 13 November 1562 Nicholas was apprenticed to Robert Brandon, the goldsmith who worked for Elizabeth I. This was a prestigious opportunity that would have given him seven years' intensive training in the craft. It instilled in him a deep familiarity with precious metals and stones, as well as the intricate jeweller's skills that he is presumed to have used in making valuable cases for the miniatures that he painted. One possible example is the 'Drake Jewel' (private collection, illustrated in *Princely Magnificence*, exhibition catalogue, Victoria & Albert Museum, 1981, no.40, p.61). Its gold case is enamelled in white, opaque pale blue, pale green, mid-blue, translucent red, blue and green, and it is set with an onyx cameo – of a black man and a white woman – and table-cut rubies and diamonds, and hung with pearls. The jewel opens to reveal a miniature of Elizabeth I by Hilliard, which is inscribed 'Ano Dni 1575 [thought to have been altered from '1585' or '1586'] Regni. 20'. The '20' has certainly been altered from '28' or '29'. Its lid contains a piece of parchment painted with the image

of a phoenix, the mythical bird used as an emblem for Elizabeth to express her uniqueness, her chastity and the continuity of the Tudor dynasty (see illustration 3).

Hilliard's apprenticeship would also enable him to conduct a parallel career as a maker of medals (see illustration 18). On 29 July 1569 Hilliard became a freeman of the Goldsmiths' Company, which allowed him to practise in his own right.

It was not unusual for a member of the Goldsmiths' to train, and work, as a painter. Another English artist who belonged to the Goldsmiths' Company was Robert Peake (c.1551–1619). Among the skills thus acquired were chasing and graving metals, which overlapped with, for instance, the field of the engraver and printmaker.

There is absolutely no evidence as to how and from whom Hilliard learned to paint portrait miniatures. It has sometimes been proposed that his teacher might have been Levina Teerlinc (c.1510/20–1576), who had been employed as a painter of pictures by, successively, Henry VIII, Edward VI and Mary I, and who presented paintings to Elizabeth I. It has, however, proved difficult to establish exactly what works by Teerlinc survive. In his treatise Hilliard never mentions Teerlinc, though he does refer to a white pigment that 'the women painters use'. He does write admiringly of the long-deceased Holbein, although his own miniature-painting style is entirely different from that of the earlier artist. There must have been various unnamed manuscript illuminators active in London – for instance, those who decorated the charters made on behalf

of Edward VI (r.1547–54), Mary I (r.1554–58) and from 1558 onwards for the new queen, Elizabeth. They could have provided a link reaching back to the techniques used by Lucas Horenbout to produce discrete portrait miniatures.

In due course Nicholas Hilliard took on apprentices of his own, under the aegis of the Goldsmiths' Company. Complete records do not survive, but we know that they included John Cobbold, apprenticed in April 1570, the German Gualter Reynolds in 1571, William Smythe in March 1573, William Franke (probably German) in July 1573, and John Pickrynge in March 1575. It is not always clear whether these individuals were destined to be active as goldsmiths and jewellers or as limners. Certainly Rowland Lockey (*c*.1565–1616), apprenticed to him in 1581, and Hilliard's own son Laurence (1582–1647/8), apprenticed in *c*.1597, did subsequently practise as miniaturists. During the 1580s (unusually, as an adult) the French-born Isaac Oliver also learned from and worked with Hilliard.

It seems that Hilliard also painted larger-scale pictures: in 1600 he undertook 'to make and bestowe on the [Goldsmiths'] Companie a faire picture in greate of her Ma^tie ...'. Such works, on wooden panel or on canvas, required wholly different techniques. Two extant images of Elizabeth I from the 1570s have been suggested as being panel paintings 'in large' by Hilliard: the so-called 'Pelican' (Walker Art Gallery, Liverpool) and 'Phoenix' (illustration 3) portraits – named after the principal items of jewellery that each image depicts the queen wearing. As confirmed by the technical investigation of the 'Phoenix' portrait that was carried out

by Rica Jones in 1995, wholly different procedures were used for the large portraits, which are painted in pigments in an oil-based medium on prepared wooden panel, than for the miniatures, which are executed with pigments in a water-based medium. For instance, no actual gold or silver was used in the larger paintings. The attribution of these two portraits therefore remains uncertain.

The status of two small circular watercolour images of a boy's head which have been thought to be very early self-portraits by Hilliard – one apparently a later copy of the other – is uncertain. (The earlier one is in a private collection and the second in the collection of the Duke of Buccleuch and Queensberry.) The inscription on the earlier one, which currently gives the date 1550 – when Hilliard was three years old – seems to have been tampered with. It is, however, just about plausible that the miniature on page 29 – a tiny posthumous watercolour image, dated 1560, of the militantly Protestant Edward Seymour, Lord Protector Somerset – could be by a teenage Hilliard. The earliest known certain limning by him as an adult is dated 1571 and depicts an *Unknown Man* (private collection). In the same year it is recorded that Hilliard had in his keeping on 'a booke of portraitures …' which Agnes, the wife of a fellow goldsmith called John Rutlinger, promised to deliver to one Thomas Clerke. It is not wholly clear what this intriguing reference means, but Rutlinger was also an engraver.

In 1572, Elizabeth I seems to have given her first sitting to Hilliard. In his treatise, he offers an account of this meeting, 'when first I came in her

highness presence to drawe'. Hilliard claims that first of all the queen discussed with him the use of shadow in painting and stated that 'best to showe ones selfe, nedeth no shadow of place but rather the open light …'. Hilliard had replied that while dark lines might make a large painting read well at a distance, miniature painting did not require this because it was meant to be viewed 'of nesesity in [the] hand neare vnto the eye'. He added that the queen immediately saw the point of this 'and therfor chosse her place to sit in for that porposse in the open ally of a goodly garden, where no tree was neere, nor anye shadowe at all …'.

Illustration 2 (National Portrait Gallery) has long been thought to be a result of this first encounter. Over the following thirty years Hilliard was to depict the queen many times. It has been estimated that at least fifteen miniatures of her by Hilliard remain – no two of which are exactly alike in every detail. Sir John Harington, writing in 1591, was to describe how he had himself seen Hilliard 'in white and blacke in four lynes only, set downe the feature of the Queenes Majesties countenance … and he is so perfect therein … that he can set it down by the Idea he hath, without any patterne' [see Cain and Thornton 1981, p.112, note 47].

The miniatures Hilliard painted in the 1570s, initially still circular in format but subsequently oval in shape following his return from France, are of exceptional refinement. They included the glamorous image of the influential Robert Dudley, Earl of Leicester (?1532–88), who was clearly a significant patron and sponsor of Hilliard.

On 15 July 1576, at St Vedast church, Foster Lane in London, Hilliard

– presumably considered a star ex-pupil – married Alice Brandon (see illustration 9), a daughter of his former master. Soon after, the couple journeyed to France, in the entourage of the English ambassador, Sir Amyas Paulet. It is presumed that Hilliard went with Elizabeth I's encouragement, as once there he entered the household of her French suitor, François, duc d'Alençon, where he is recorded as 'Nicholas Belliart, peintre anglois'. There he met the poet Ronsard, about whom he later wrote in his treatise, and other scholars, including Blaise de Vigenère, who penned a short account of his impressions of Hilliard and arranged for him to make two small oval woodblock portraits of the duc and duchesse de Nevers, to be printed in a document marking the founding of a charity. Moreover, it has recently been noticed that 'Nicholas Heliart (compagnon anglais)' appears in the Paris goldsmiths' records, implying that he set up a workshop there. While in France, Hilliard painted an exceedingly elegant self-portrait, as well as a fine depiction of his wife Alice.

It is not clear when Hilliard himself returned to London. Alice seems to have gone ahead, for the couple's first child, Daniel, was baptised in London in May 1578. Nicholas probably came back later the same year. It is thought that he had hoped to make a substantial amount of money in France, but failed. Certainly at around this time he seems to have become involved in a curious and ultimately unsuccessful enterprise – with two Netherlanders, the 'picture maker' Cornelius de Vos and another painter Arnold, or Arthur, Brounckhurst (active from *c*.1565) – to prospect for gold

in Scotland. The eventual failure of their project forced van Brounckhurst to remain in Scotland as painter to the young Stuart king James VI. It seems clear that in temperament Hilliard was something of a risk-taker.

Erna Auerbach suggests that Hilliard's usual payment for an unframed miniature was about £3 – the sum he received in 1585–6 for an image of the Earl of Northumberland, and again in 1592 for 'the drawing of one picture' for Bess of Hardwick, the Countess of Shrewsbury.

In c.1578–9, Hilliard moved into a house in Gutter Lane, off Cheapside, in London, leased from the Goldsmiths' Company. For the next 35 years, this property (called 'The Maydenhead') must have been where he both resided and had his studio. It was also where six further children were raised: Elizabeth (born October 1579), Francis (born December 1580), Laurence (born March 1582), Lettice (born May 1583), Penelope (born October 1586) and Robert (born March 1588).

Although Hilliard seems not to have held a formal court post in England, an interesting surviving draft document, dated 1584 but apparently never enacted, would have given the painter of large-scale images, George Gower (active from 1573, died 1596), a monopoly for painting all portraits of Elizabeth I, with the exception that Hilliard would 'make purtraicts, pictures, or proporcons of our body and person in small compasse in lymnynge only, and not otherwise' (see Auerbach 1961, p.20). In 1591 Hilliard received a gift of £400 from Elizabeth I, presumably for services rendered.

From 1584 to 1586, Hilliard, calling upon his training as a goldsmith,

collaborated with Dericke Anthony, 'Graver to the Mint', to make Elizabeth I's second Great Seal. A small, circular full-length drawing of the queen, in pen and ink and wash over pencil, in the British Museum, probably relates to this project. The 1580s were perhaps the peak of Hilliard's career. During this decade he portrayed many senior court figures in miniatures of exceptional assurance and bravura.

In 1591, Hilliard's father-in-law and former master, Robert Brandon, died. It has been observed that Brandon specifically cut Nicholas, and his children, out of his will. Whether this indicates a personal animosity or was merely a practical measure to prevent money going directly into the hands of Hilliard's creditors, is unclear. Surviving miniatures demonstrate that Hilliard was now not only depicting, and thus working for, members of the court but also for those at less elevated levels of society – for example, the person who commissioned the miniature of a middle-class lady (illustration 27) – and thus presumably for anyone who could pay him. References to financial problems recur regularly throughout Hilliard's life – and indeed he alludes to such difficulties in his treatise.

In 1595, Elizabeth's favourite, Robert Devereux, 2nd Earl of Essex, now Master of the Horse, and the political heir of Hilliard's old patron Leicester, helped the artist repay the mortgage on his house. In 1599 Hilliard was granted an annuity of £40 a year. It was around this time that he must have been drafting his treatise.

1600 was evidently a year of significant financial crisis for Hilliard. Elizabeth I's Privy Council, 'signifyinge her Ma^ties pleasuer', had to

intervene with the Goldsmiths to renew his lease on his Gutter Lane home. In return, Hilliard agreed to paint for the Goldsmiths the 'faire picture in great' of the queen referred to earlier. This work is not known to have survived. In 1601 he wrote to Elizabeth's Lord Secretary, Robert Cecil, mentioning that he had trained many other limners and requesting the queen's permission to travel abroad to escape his creditors.

Following Elizabeth I's death in March 1603, Nicholas Hilliard became the chosen limner of her successor James VI of Scotland – the son of Mary, Queen of Scots – who had become James I of England. James was to continue to employ him, both as a miniature painter and a medal-maker, for the remainder of his career. Hilliard's work seems, however, no longer to have been seen as at the forefront of current style, and his former pupil Isaac Oliver was formally employed not only by James I's more aesthetically attuned wife, Anne of Denmark (1574–1619), but also by his eldest son Henry, Prince of Wales, once the prince and his household were able to take control of his own image.

On 7 June 1605, Hilliard's son and pupil, Laurence, also became a freeman of the Goldsmiths' Company. From the inscription added later to the miniature of Alice Hilliard (illustration 9) – which refers to her as Nicholas's 'first wife' – we learn that he must have remarried. An 'Alice Hillyard' was buried at St Margaret's, Westminster, on 16 May 1611. On the other hand, a 'Nicholas Hilliard' was recorded as marrying a 'Susan Gyzard' on 3 August 1608 at St Mary at Hill in London. Was this the miniaturist's second wife? It has been observed that there were a number

of Hilliards and Hillyards in London, and indeed in Westminster, at this period. In 1613, the artist made over the Gutter Lane workshop to Laurence, and he himself apparently moved to Westminster. Four years later, he was granted a monopoly to engrave and print portraits of the royal family; nevertheless, in the same year, 1617, he was imprisoned in Ludgate for debt.

On Christmas Eve 1618, Nicholas made his will (National Archives, Prob. 11/133/2). It does not mention his second wife, suggesting that she had already died. The exact date of his own death is not known, but he was buried at St Martin-in-the-Fields – the church located near the western end of the Strand – on 7 January 1619.

Hilliard's technique

The most detailed studies of Hilliard's working methods were carried out by the late Jim Murrell. Over a period of more than twenty years, Murrell examined not only the miniatures in his care at the Victoria and Albert Museum in London, but also those in many other public and private collections. Subsequent researchers such as Alan Derbyshire and Nicholas Frayling are continuing such examinations.

The principal means of investigation – visual examination under high magnification – is comparatively straightforward and available to those with special access to such works, but Murrell was the first to augment

this with other procedures. Study under tangential illumination shows up minute variations in the relief of the paint surface; ultraviolet fluorescence helps detect areas of restoration and the use of pigments only available at later dates; infrared reflection is used to distinguish certain pigments; and x-radiography reveals patterns of usage of pigments, especially lead-based ones.

For works of such small dimensions, taking paint samples is out of the question, but the non-destructive, non-invasive technique of Raman microscopy can provide significant evidence about pigments used in a specific miniature. Raman gives a 'fingerprint' spectrum of a minute area of a material *in situ* that can then be identified by referring to a library of spectra. The high cost of the Raman instrument, however, means that it has as yet been little used.

In his short book, *The Way Howe to Lymne,* Jim Murrell described the technique of Hilliard's adult works from the 1570s onwards. Having acquired his pigments, mainly from the apothecaries, Hilliard had to prepare them for use. They would need to be ground or washed or otherwise refined, and then mixed with water and gum arabic. Certain colours would also need the addition of a little sugar, to prevent them from cracking.

Like Lucas Horenbout, Hans Holbein II, and the unidentified painter, or painters, of the mid-century miniatures that have sometimes been attributed to Levina Teerlinc, Hilliard worked in pigments in a water-based medium on a piece of vellum that had been pasted on to a piece of

card. He first laid in a base for the face area in flesh-toned colour, referred to as the 'carnation', over which he drew in the initial lines, and then painted in the features with transparent hatching strokes, using a very fine paint brush. Hilliard generally used a much paler 'carnation' than his predecessors in England and his hatches resemble the strokes of the engraving tool, the burin, employed by printmakers such as the earlier German artist and engraver, Albrecht Dürer. Indeed, in his treatise Hilliard specifically commends Dürer's 'fine well graven portrature'.

During the 1570s, Hilliard used a rich blue background, generally of the mineral pigment azurite (called 'bice' at that time). This rather coarse pigment was not easy to apply: Hilliard generally floated it on with the brush to achieve a thick, smooth finish, over which he usually added an inscription, in a distinctively flamboyant script, using gold paint, stating in Latin the year of painting and the sitter's age, and sometimes adding a motto. Meanwhile, the costume areas were painted in opaque body-colour. To have been presented with one of these miniatures – depicting the features of a person that one knew, and perhaps loved – must have been an extraordinary experience.

Hilliard's portrait miniatures demonstrate a number of innovations that must have emerged from his training as a goldsmith – not only his use, from the outset, of powdered real silver and gold for painting in items of jewellery and armour, but also his procedure for representing pearls. For these he began with a rounded blob of white lead paint on to which he placed a dot of silver, which he then burnished. Unfortunately, these

dots (and any other silver-painted areas) have often oxidised over time and tarnished irrevocably to black. Today we must use our imagination, or computer visualisation, to recapture their original sparkling impact.

From the early 1570s onwards, Hilliard also used an innovatory method to represent precious stones in the elaborate jewellery worn by so many of his sitters. Over a burnished silver ground, using a hot needle, he applied hot resin coloured with the appropriate hue: red to represent rubies, green for emeralds and so on.

It is frequently observed that Hilliard's technique is extremely linear. Commentators contrast it with that of his predecessor Hans Holbein II, whose use of line presented a sense of contour. Hilliard, as he himself stated in his treatise, explicitly avoided the use of heavy shadows, which he considered entirely inappropriate to small-scale painting.

Hilliard wrote: '... let that your first lyne be the forehead stroake ... Soe then you shall proceed by that scalle ... to doe all proportionablye to that bignes ...'. As Murrell has pointed out, Hilliard is here articulating his actual practice of relating each of the internal forms of the facial features to one carefully proportioned line. Establishing a firm outline in this way gave his work the linear quality that typifies it. We should also be aware that the original appearance of his works will have been less flat, because the more fugitive red pigments used to hatch in the contours of the features, such as red lake, tend to fade with exposure to light.

Following his return from France in 1578 Hilliard adopted an oval format – which had been in use in France from at least the 1550s – rather

than the circular (and occasionally rectangular) shape previously seen in England. During the 1590s Hilliard began to depict his sitters in front of a rippling red curtain, instead of a flat blue background. He carried this out using the so-called 'wet–in–wet' technique by which a darker mixture of red lake pigment was floated into a still–damp lighter layer. After 1600, Hilliard simplified this procedure by painting a wet dark ground of lake and then just lifted out the highlights with a dry brush (see, for instance, the curtain behind James I in illustration 28).

The decoration around the edge of his miniatures, which was generally a piece of text with a border at the extreme edge, was clearly a focus for Hilliard. In his earlier miniatures, his dashing script, which (unlike inscriptions painted by Horenbout and Holbein) includes arabic rather than roman numerals, implies that he must have received specific training in calligraphy. The signature he employed in the more everyday side of his life, to sign documents, was equally extravagant – as, for example, the italic 'Nicholas Hillyarde' (this seems to have been his own preferred spelling of his name) appended to a financial agreement in 1585 (reproduced in Auerbach 1961, p.22). In his later miniatures he turned the edge into a decorative band with a gilded inscription using capital letters (see, for example, illustration 28).

Hilliard's treatise, and the evidence of the extant works, suggests that he worked directly on to the vellum, with the sitter before him. He does not seem to have made any intermediary drawing on paper first, as Holbein, for instance, had done. It is thus not clear how repetitions of

images were achieved. Even now, a number of Hilliard's portrait miniatures survive in more than one version – a miniature similar to illustration 17, for example, is now in the collection at Belvoir Castle. With the accession of James I in 1603, there seems to have been an unceasing demand for royal limnings. It is evident that Hilliard's younger son, Laurence, was by then working with him, and it is probable that he had other assistants, perhaps including his former apprentice Rowland Lockey, who is known to have subsequently also painted 'in large'. It may be that Nicholas himself found turning out such multiples uninteresting and, given his working methods, even difficult. He was of course now in his mid-fifties, and if he had developed age-related eyesight problems he might have found the requisite close working hard. Certainly the quality of his miniature production does diminish in his later years. Moreover, as stated earlier, the more fashionable court sitters, except for the aesthetically conservative king, were now turning to Isaac Oliver, whose more strongly modelled images, using stippled shadows, were evidently preferred.

As Graham Reynolds has observed, in a miniature by Hilliard the head is generally placed three-quarters left, which gives a strongly defined profile to the outer curve of the face. The iris is circular and, especially striking, the eyelid is drawn with a bold, dark, flattish stroke. The hatched modelling of the features is softly executed, while all the details of the costume are represented in meticulous and minute detail. To depict lace, for instance, thick white paint is precisely applied with the brush over a base layer. Standing proud in this way gives the paint a literal

three-dimensionality. Indeed, in his treatise Hilliard specifies the use of a number of white pigments, particularly three different grades of lead white (or 'ceruse'), for particular purposes as well as an unusually wide range of differing blacks. He was a consummate technician, acutely aware of the materials and techniques with which he worked.

Environment

In his treatise, Hilliard demonstrates his meticulous working practices by emphasising the need for the right painting environment and for personal cleanliness and self-discipline on the part of the limner. This latter was bound up with his rather anxious construction of the portrait miniaturist as a gentleman.

The working room should be warm, and free of dust and polluting coal smoke which could affect the surface of a limning. It should be lit from a single source, ideally a north-north-east window that would produce an even light.

According to Hilliard, the painter had to take care not to let any dandruff or specks of spittle fall on to his work, and to wear only silk fabrics which would not shed pile or hairs on to the picture surface. Silk fabrics were also a sign of gentlemanly status. Limners should live temperately lest the 'guift of god' of artistic ability should be soon 'taken from them againe by some sudaine mischance, or by their evell coustomes,

their sight, or stedines of hand decay ..' – all of which would have been disastrous for a miniature painter.

The artist also needed to have congenial manners, since a painted miniature was the result of a personal encounter with a wealthy, possibly aristocratic, individual. During a lengthy session it was essential to keep a sitter engaged; he or she had to remain calm and still. Interestingly, Hilliard advocated the use of scents in the room: 'sweet odors comforteth the braine and openeth the vnderstanding, augmenting the delight in *Limning* . . . '. He advised that discreet conversation or reading, music or 'quiet merth' made the time pass quickly 'both in the drawer, and he which is drawne'. Given his success, it is evident that the personable Hilliard was able to keep his sitters agreeably entertained for the length of time that it took to take a likeness.

It was through putting his subjects at their ease in this way that Hilliard was able to elicit the smiles and other momentary and characteristic changes of expression that he vividly describes in his treatise. Although Hilliard may never have been sufficiently rewarded for his skill, he clearly turned out a product that succeeded – one that continued to suit the needs of the court elite for more than thirty years.

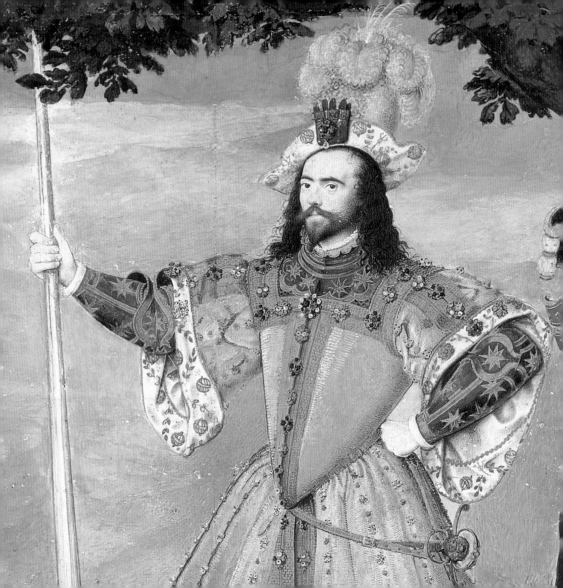

THE ILLUSTRATIONS

1 Nicholas Hilliard, attributed

Edward Seymour, Duke of Somerset

1560, 33.5 mm diameter
Watercolour on vellum stuck to pasteboard
The Duke of Buccleuch and Queensberry KT

This posthumous image of Lord Protector Somerset (?1506–52) is inscribed around the edge 'EDWARDE.DUKE OF SOMERSET.ANNO DOMNI.1560 NH [as a monogram]' in the manner of a medal. Presumably copied from a since-lost large-scale original, this is the earliest known likely work by Hilliard.

The uncle of the young Edward VI, and Lord Protector of England, Somerset was a major promoter of the Reformed religion in England. The youthful Hilliard might well have seen, or been shown, a portrait of him in such a staunchly Protestant household as that of John Bodley, with whom he had lived as a boy in Geneva and perhaps subsequently in London.

The unusual background is of gold, washed over an ochre ground.

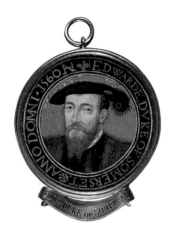

2 Nicholas Hilliard

Elizabeth I

1572, oval 51 x 48 mm
Watercolour on vellum stuck to pasteboard
National Portrait Gallery, London
(no.108)

Inscribed 'Ano Dni. 1572. Ætatis suæ 38:–', with a crowned 'E' to the left,
and a crowned 'R' to the right, this early work is thought to be Hilliard's
first miniature of Elizabeth I. There has been some later repainting of the
face and ruff areas, but examination under ultraviolet light has shown
more clearly the original drawing of the queen's features. In his treatise,
Hilliard described his first sitting with the queen, for which she elected to
sit 'in the open ally of a goodly garden where no tree was near, nor anye
shadow at all'.

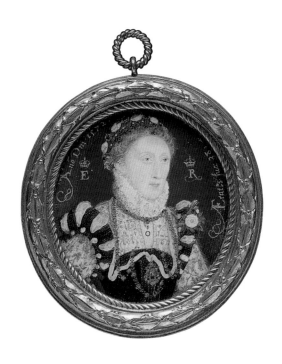

3 Nicholas Hilliard, attributed

Elizabeth I ('The Phoenix Portrait')

c. 1575, 78.8 x 61 cm
Oil on panel (painting in large)
National Portrait Gallery, London
(on long loan to Tate, where no.L00128)

Hilliard is recorded as having also painted 'in greate' (that is, on a larger scale), although no wholly undisputed portraits of this type survive. In 1933 it was suggested that this painting on wooden panel – and a similar image in reverse in the Walker Art Gallery, Liverpool – might be the work of Hilliard, through comparison with his 1572 miniature of the queen (page 31).

 This image takes its name from the jewelled phoenix pendant that hangs just above the queen's hand. The mythical phoenix was a unique bird that cyclically burnt itself to ashes out of which it would rise rejuvenated – a symbol much used for Elizabeth I from the 1570s onwards.

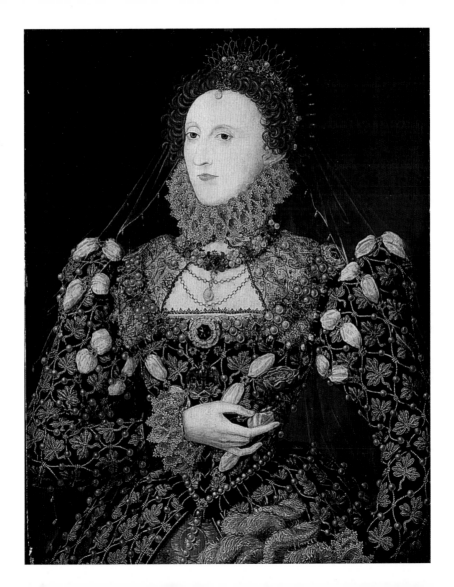

4 Nicholas Hilliard

Unknown Man

1572, 46 mm diameter
Watercolour on vellum stuck to playing card
Fitzwilliam Museum, Cambridge
(no.3899)

Inscribed 'Ano Dni.1572 Ætatis Sue' in Hilliard's characteristically stylish italic script, this is another miniature whose inscription has at some time been altered: the sitter's age has been removed, possibly because it did not tie in with a previous erroneous identification of the sitter as Edward Courtenay, Earl of Devon (1526–56), a great-grandson of Edward IV. Courtenay had in fact died many years before this work was painted.

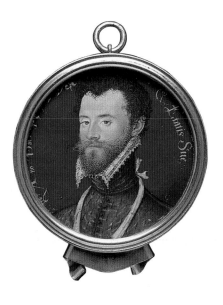

5 Nicholas Hilliard

A Lady, possibly Lady Margaret Douglas

1575, 45 mm diameter
Watercolour on vellum stuck to pasteboard
Copyright © Rijksmuseum Amsterdam
(no.A 4323)

Once again, we see Hilliard's flamboyant gold lettering, 'Ano. Dni. 1575. Ætatis. Svæ', but in this case the sitter's age seems never to have been painted in. The costly blue pigment ultramarine has been used for the background.

The lady may be Margaret Douglas (1515–78), Countess of Lennox, mother of Henry, Lord Darnley, the second husband of Mary, Queen of Scots. Save for the missing age, this miniature fits the description of one by Hilliard inventoried in the collection of Margaret's great-grandson, Charles I. In 1575 the countess was released from the Tower of London, where she had been imprisoned for contriving the marriage of her second son, Charles, with Elizabeth Cavendish, daughter of the celebrated Bess of Hardwick. Another version, with the face completely repainted later, is in the Fitzwilliam Museum, Cambridge.

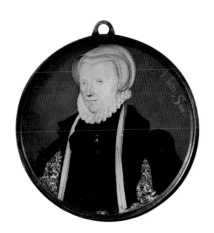

6 Nicholas Hilliard

Robert Dudley, Earl of Leicester

1576, 45 mm diameter
Watercolour on vellum stuck to pasteboard
National Portrait Gallery, London
(no.4197)

Inscribed 'Ano.Dni.1576 Ætatis Sue 44.', this miniature is in especially
good, unfaded condition, although it has been a little trimmed down.
Robert Dudley (?1532–88) was Elizabeth I's favourite, and indeed aspired
to marry her. From 1558 he was her Master of the Horse – a position
traditionally close to the monarch – and was a significant dispenser of
political patronage.

 Leicester was one of Hilliard's principal patrons and evidently
interceded for him with other courtiers. He may have been a godfather
to some of Hilliard's seven children, many of whom bore Dudley family
names. Leicester was clearly very interested in his own image and
numerous larger-scale paintings of him also survive.

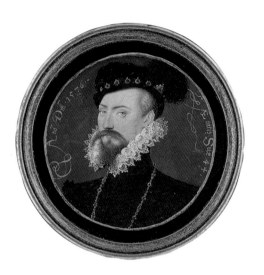

7 Nicholas Hilliard

A Lady, possibly Marguerite de Valois

1577, oval 57 x 44 mm
Watercolour on vellum stuck to pasteboard
Private Collection
© Christie's Images Ltd

Inscribed 'Ano Dni. 1577', this was painted by Hilliard in France. It was
previously thought to depict a 'Mademoiselle de Sourdis' until in 1983 it
was suggested that the sitter was Marguerite de Valois, Queen of Navarre
(1552–1615) – subsequently the notorious 'reine Margot'. Comparisons
with known drawings of the queen have not, however, proved conclusive.
Marguerite was the sister of Elizabeth I's French suitor, François,
duc d'Alençon, whose service Hilliard entered as a *valet de chambre*. In
the summer of 1577, the English ambassador in France – and probably
Hilliard – travelled south, perhaps as far as the Navarre court.

There has been some damage and restoration to the face.

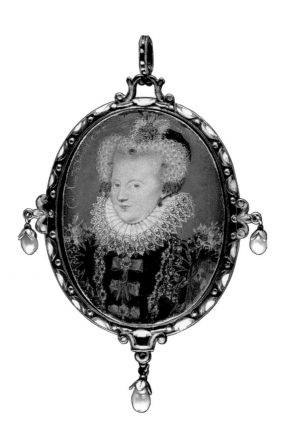

8 Nicholas Hilliard

Self-portrait

1577, 41 mm diameter
Watercolour on vellum stuck to pasteboard
V&A Images,
Victoria and Albert Museum, London
(P.155–1910)

The miniature is inscribed 'Anº Dni / 1577; Ætatis Suæ / 30'. In the early eighteenth century, we know that this still had a painted border, similar to that still around illustration 9, which bore a Latin inscription translatable as 'Nicholas Hilliard Goldsmith, Engraver, and famous Illuminator of the most Serene Queen Elizabeth, in the Year 1577 and the 30th of his Age'.

Hilliard must have painted this in France, where he had gone in the entourage of the English ambassador, Sir Amyas Paulet, in the later part of 1576. Here he presents himself as a gentleman – stylishly elegant.

The edges of this miniature have sustained damage, and there has been some restoration to the ruff.

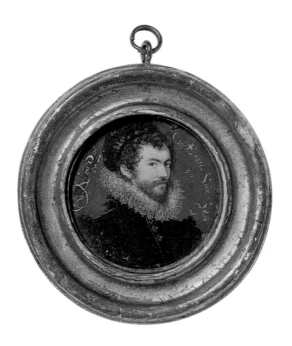

9 Nicholas Hilliard

Alice Brandon, Mrs Hilliard

1578, oval 59 x 57.5 mm
Watercolour on vellum stuck to pasteboard, stuck to a larger circular card
V&A Images,
Victoria and Albert Museum, London
(P.2–1942)

This portrait of Hilliard's wife Alice, at the age of 22, must have been painted while the couple were in France. Around her head is inscribed 'Ano Dni . 1578 * Æs S. 22', while his 'NH' monogram can be seen to left and right. Pinned to her black gown is a fresh pink rose; a green head of corn can be seen at the left-hand edge of her shift.

The border, its Latin text referring to Alice as the painter's first wife, was clearly added later. With the Hilliard family arms to the left and the Brandon ones to the right, this inscription reads:
'ALICIA BRANDON.NICOLAI HILLYARDI.Q/VI PRPRIA MANV DEPINXIT VXOR PRIMA.'

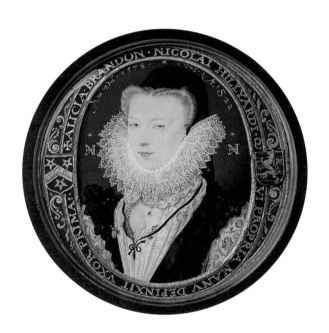

10 Nicholas Hilliard

Richard Hilliard

157[?7], 41 mm diameter
Watercolour on vellum stuck to pasteboard
V&A Images,
Victoria and Albert Museum, London
(P.154–1910)

This portrait of Hilliard's father is inscribed 'Ætatis suæ.58: Anno Dni.
1577'. Richard Hilliard (1518/19–94) was a goldsmith, and was based in
Exeter. There is some doubt as to whether the repainted final '7' of the
date here was originally another number. The '8' in the sitter's age – '58' –
is also suspect. Hilliard spent the year 1577 away in France, so if the date
were indeed correct he would presumably have produced this image
from memory.

The blue background is painted in the very expensive pigment ultra-
marine, a feature found on few other surviving works by Hilliard before
the 1590s. The edges have suffered water damage and have been
retouched using a coarse azurite pigment. Like the previous two Hilliard
family miniatures, this one also once had a lettered border.

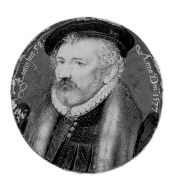

11 Nicholas Hilliard

Mary, Queen of Scots

1578/9, 51 x 39.5 mm diameter (miniature alone)
Watercolour on vellum stuck to playing card, extended later
V&A Images,
Victoria and Albert Museum, London
(P.24–1975)

From 1569 the exiled Mary, Queen of Scots (1542–87) was in the custody
of Lord and Lady Shrewsbury in the English Midlands. The costume in
which she is seen here dates from the end of the 1570s. Hilliard is
thought to have returned from France no earlier than August 1578. The
circumstances in which this miniature was painted are unknown. A
second version, in the Royal Collection, is in less good condition,
although its background is painted in expensive ultramarine. While the
present work uses the cheaper azurite, the sitter's costume is in this case
shown in greater detail.

Hilliard's image here would, in the early seventeenth century, become
the basis for a number of large-scale posthumous paintings of Mary that
are, intriguingly, inscribed with the date '1578'.

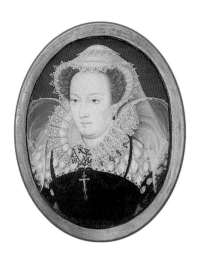

12 Nicholas Hilliard and others

Charter for Emmanuel College, Cambridge

1584, initial: 187.3 x 165.1 mm
Watercolour and ink on vellum
With Permission of the Master and Fellows of Emmanuel College, Cambridge

This charter authorised the puritan Sir Walter Mildmay (1520/21–1589) to found Emmanuel College, Cambridge. Two years previously, Lord Leicester had recommended Hilliard to Mildmay. The very sophisticated antique decoration of the top-left corner of the charter is clearly by more than one hand. It has been suggested that the figure of Elizabeth I was painted by Hilliard. This seems to be so, most notably the face and ruff.

Such a multi-handed process certainly did occur, for example for the British version of the 1604 Anglo-Spanish-Flemish Somerset House peace treaty (Archivo General de Simancas), in which the rather crude top-left figure of James I by an unknown limner is topped by a finely painted portrait head which, although somewhat rubbed, is clearly by Nicholas Hilliard himself.

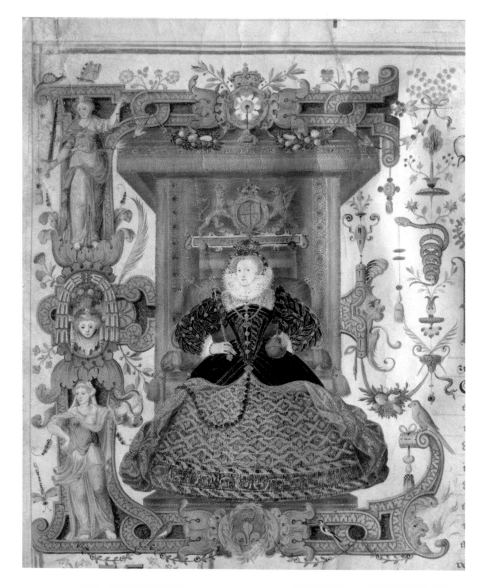

13 Nicholas Hilliard

Unknown Lady

1585–90 (in ivory box), oval 46 x 39 mm
Watercolour on vellum stuck to playing card
V&A Images,
Victoria and Albert Museum, London
(P.2–1974)

The unknown sitter's head and wide lace ruff fill the picture space. This, along with her rather conspiratorial smile, produces an effect of particular intimacy. In his treatise, written a decade later, Hilliard describes the necessity of catching 'thosse louely graces wittye smilings, and those stolne glances wch sudainely like lighting passe and another Countenance taketh place …' He also observed how '… in smilling … the eye changeth and naroweth, houlding the sight yust between the lides as a center, howe the mouth alittel extendeth both ends of the line vpwards …'.

Still in its early turned ivory box, this miniature is comparatively unfaded. The silver that Hilliard used for the highlights on the pearls in the lady's hair has here tarnished to brownish rather than the usual black.

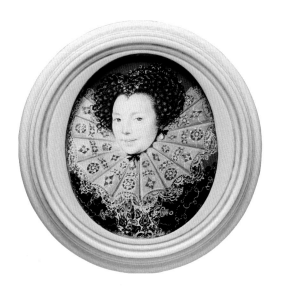

14 Marcus Gheeraerts II (1561/2–1636)

Unknown Lady

c.1595, oil on panel
92.7 x 76 cm
© Tate, London 2004
(no. T07699)

All the surviving works by the Bruges-born English painter Marcus
Gheeraerts II are large-scale portraits. Gheeraerts's earliest known paint-
ings are dated 1592, around which time he also produced the immense
'Ditchley' portrait of Elizabeth I (National Portrait Gallery). He became
the leading portraitist of the 1590s.

Certain pictorial elements first introduced on a small scale by Hilliard
subsequently appear in Gheeraerts's work. It is extremely rare for a
sixteenth-century British sitter to be depicted smiling – as this heavily
pregnant lady is – but this feature is also seen in some miniatures by
Hilliard of the 1580s (see illustration 13). This extraordinarily direct image
is datable, from the costume, to the mid-1590s. Gheeraerts is believed to
have possessed a manuscript copy of Hilliard's treatise.

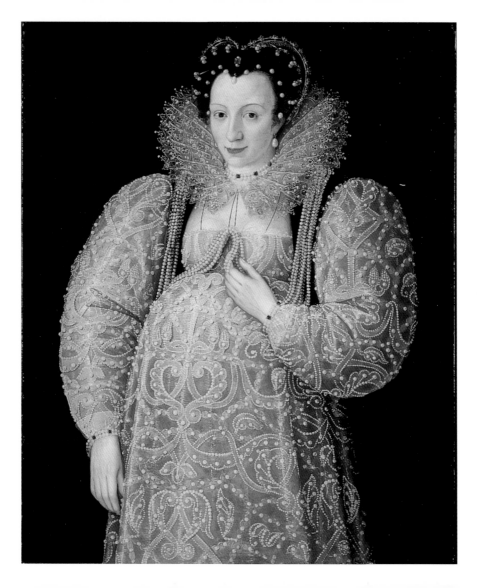

15 Nicholas Hilliard

Sir Walter Ralegh

*c.*1585, oval 48 x 39 mm
Watercolour on vellum stuck to pasteboard
National Portrait Gallery, London
(no.4106)

Sir Walter Ralegh (?1552–1618) was a favoured courtier of Elizabeth I, by whom he was knighted in 1584, and an explorer who promoted the colonisation of Virginia in America. Famed for his good looks and stylish demeanour, Ralegh is here depicted in a costume with French elements, such as the bonnet placed far back on the head. His large cartwheel ruff was a fashion worn in the mid-1580s.

Ralegh later took part in expeditions to Cadiz and the Azores. Following Elizabeth's death in 1603, he was imprisoned for many years by James I who had him executed on his return from a gold-seeking voyage to the New World.

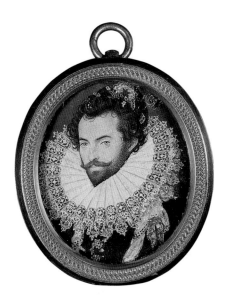

16 Nicholas Hilliard

Charles Blount, later Earl of Devonshire

1587, oval 43 x 35 mm
Watercolour on vellum stuck to pasteboard
By permission of the Trustees of the Carew Pole Family Trusts.
Photograph: Photographic Survey, Courtauld Institute of Art.

Charles Blount, Baron Mountjoy and later 1st Earl of Devonshire (1563–1606) fought in the Low Countries during the 1580s and afterwards became Lord Deputy in Ireland. His good looks were reputed to have gained him favour with Elizabeth I, and he was famously the lover of Penelope Devereux, Lady Rich (the 'Stella' immortalized in Sir Philip Sidney's sonnets – see illustration 22). In this miniature, Blount is shown wearing a gorget – armour for the neck – and is thus portrayed as both a warrior and a lover. The inscription (left) – 'Amor amoris premium' – may translate as 'Love is the reward of love' – while (right) 'Ano Dni. 1587:' gives the date of this work.

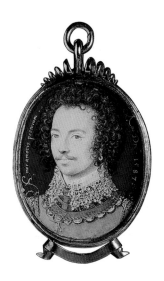

17 Nicholas Hilliard

Young Man, possibly Robert Devereux, 2nd Earl of Essex

1588, oval 40 x 33 mm
Watercolour on vellum stuck to pasteboard
The Metropolitan Museum of Art, Fletcher Fund, 1935. (35.89.4)
Photograph © 1994 The Metropolitan Museum of Art

In 1943 Carl Winter observed that this work, inscribed 'Ano.Dni.1588.
Ætatis Suæ.22.', and a similar, but uninscribed, head-and-shoulders
miniature in the collection of the Duke of Rutland at Belvoir Castle, and
the celebrated oval full-length miniature of *A Young Man Among Roses*
(V&A, P.163–1910) all appear to depict the same dark-haired young man.

In 1957, David Piper proposed that the subject was Robert Devereux,
2nd Earl of Essex (1566–1601) who would indeed have been 22 in 1588,
as inscribed on the present miniature. Elizabeth I favoured Essex greatly
and created him Master of the Horse in 1587. The high point of his career
was his successful attack on Cadiz in 1596, but following his less
successful appointment as Governor-General of Ireland, he attempted to
raise a rebellion and was executed for treason in 1601. From 1596
onwards the dark-haired Essex wore a thick beard, which surviving
portraits clearly show as bright auburn.

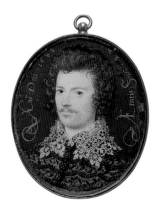

18 Nicholas Hilliard, attributed

Dangers Averted

*c.*1589, height 60.08 mm x width 52.2 mm
Gold medal, cast and chased
Fitzwilliam Museum, Cambridge

This medal is inscribed on the obverse 'DITIOR. IN. TOTO NON.
ALTER. CIRCVLVS' ('No other circle in the whole world more rich'),
and on the reverse, 'NON. IPSA. PERICVLA. TANGVNT.' ('Not
even dangers affect it').

First attributed to Hilliard in 1908, this refined medal celebrates the
sense of deliverance in England following the defeat of the Spanish
Armada in 1588. The powerful frontal image of Elizabeth I on the obverse
echoes those on both the 1584 Great Seal and a drawing for a Great Seal
of Ireland of about 1595, both designed by Hilliard.

The reverse shows, beneath a stormy sky, an island with tiny buildings
and a great bay tree, surrounded by a rough sea dotted with ships and sea
creatures. It was believed that the bay tree gave protection from lightning.

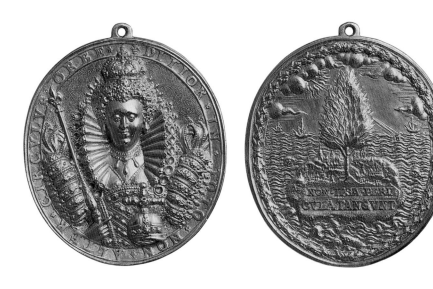

19 Nicholas Hilliard

Sir Christopher Hatton

*c.*1588–91, oval 56 x 43 mm
Watercolour on vellum stuck to playing card
V&A Images,
Victoria and Albert Museum, London
(P.138–1910)

This is a rare example of a miniature that shows a full-length figure in an interior, a format developed by Hilliard in the later 1580s. Sir Christopher Hatton (1540–91) first caught Elizabeth I's eye while dancing in a court entertainment. He became captain of her bodyguard in 1572 and Lord Chancellor in 1587. It is with the regalia of this latter post – the Great Seal bag embroidered with the royal arms – that he is depicted here. In his treatise, Hilliard observed that Hatton, though generally considered a handsome man, had an unusually low forehead.

Under magnification, Jim Murrell discerned graphite lines that he thought might be the remains of a preliminary pencil sketch. It is extremely unusual to find graphite underdrawing in miniatures of this period. A second version is in the collection of the Duke of Rutland.

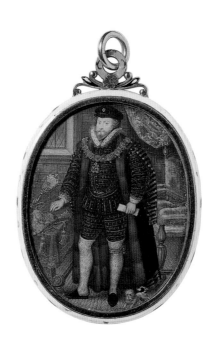

20 Nicholas Hilliard

George Clifford, 3rd Earl of Cumberland

*c.*1590, rectangular 258 x 176 mm
Watercolour on vellum on fruitwood panel
© National Maritime Museum, London

George Clifford, a courtier and maritime adventurer, inherited vast estates in Yorkshire and Cumberland.

This large rectangular miniature apparently records his appointment in 1590 as Queen's Champion, the convenor of the annual Elizabethan Accession Day 'tilts' or jousting pageants. Hilliard depicts Cumberland holding his tournament lance, in the fantastical costume of the 'Knight of Pendragon Castle', with a blue surcoat over his fine star-patterned Greenwich-made armour. The white silk lining is symbolically embroidered with sprigs of olive and armillary spheres, while a jewelled glove, presumably a favour from Elizabeth I, is fixed to his hat. A view across the Thames towards Whitehall Palace is on the left. Hilliard derived this composition from a Netherlandish engraving of a pike-bearer by Hendrick Goltzius, published in 1582.

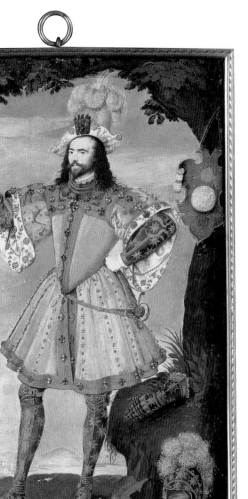

21 Marcus Gheeraerts II

Captain Thomas Lee

1594, 230.5 x 150.8 cm
Oil on canvas
© Tate, London 2004
(no.T03028)

The full-length image of a subject seen in an outdoor environment, as
here, was extremely rare in British portraiture prior to the 1590s when it
seems to have been made fashionable by the large-scale painter, Marcus
Gheeraerts II. In this he may have been inspired by Hilliard's small-scale
works of the late 1580s onwards (see, for example, illustration 20).

Captain Thomas Lee (1552/3–1601), serving in the English colonial
forces in Ireland, is portrayed symbolically in the role of the Roman hero
Gaius Mucius Scaevola, who had shown courage, and achieved acclaim
and reward, after entering the enemy Etruscan camp in Etruscan disguise.
Lee is apparently here depicted in a fictive Irish landscape, wearing the
bare-legged style that Irish foot soldiers were thought (erroneously) to
favour.

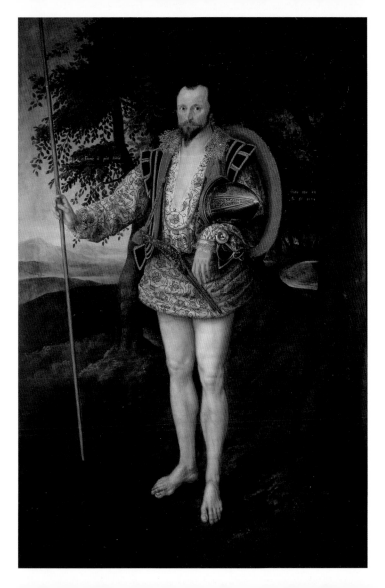

22 Nicholas Hilliard

A Lady, possibly Penelope Devereux, Lady Rich

*c.*1590, oval 57 x 46 mm
Watercolour on vellum stuck to pasteboard
The Royal Collection © 2004, Her Majesty Queen Elizabeth II
(RCIN 420620)

This is in the same full-length format as Hilliard's image of Sir Christopher
Hatton (illusration 19), although as both subjects face in the same direction
they cannot be a pair.

The sitter's golden hair and very dark eyes have led to the tentative
suggestion that she may be Penelope Devereux (?1563–1607), sister of
the 2nd Earl of Essex (see illustration 17), step-daughter of Robert
Dudley, Earl of Leicester (see illustration 6), and the 'Stella' of Sir Philip
Sidney's poetry. Hilliard is known to have painted miniatures of her in
1589 and again in 1590 – one of them was the subject of a sonnet by
Henry Constable 'To Mr Hilliard: upon occasion of a picture he made of
my Ladie Rich'. This identification must, however, for the present remain
speculative.

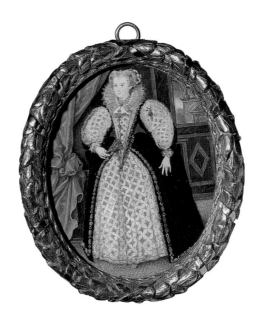

23 Nicholas Hilliard

Unknown Lady

c.1595, oval 73 x 53 mm
Watercolour on vellum stuck to playing card
Fitzwilliam Museum, Cambridge
(no.3898)

The pearls in the sitter's hat have Hilliard's characteristic silver high-
lights, now oxidised. Her dark dress is decorated with gold. Pinned to her
sleeveless black gown is a sprig of fresh green leaves with a red berry.

A nineteenth-century notion that this blue-eyed sitter was the
celebrated (brown-eyed) Lady Anne Clifford (1590–1676) cannot be
sustained on grounds of age.

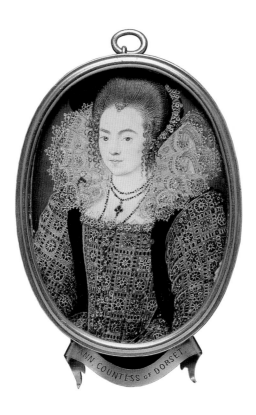

ANN. COUNTESS OF DORSET.

24 Nicholas Hilliard

Unknown Lady (unfinished)

*c.*1595, rectangular 182 x 122 mm
Watercolour on vellum, relaid on modern card (in 1939)
Fitzwilliam Museum, Cambridge
(PD. 209–1961)

This remarkable uncompleted image reveals the basics of Hilliard's
technique. The wired gauze 'wings' behind the ruff of the smiling
unidentified sitter suggest that she is a senior court figure. Her golden
hair and the red velvet hanging that has been painted in behind her are
the only main areas to have been coloured. The face alone is
comparatively complete, although now somewhat faded, and the string
of pearls at her neck is sufficiently finished to have been given silver
highlights, which have now tarnished to black.

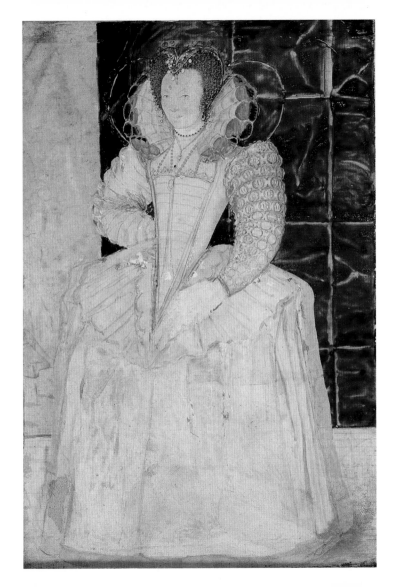

25 Nicholas Hilliard

Henry VIII (from the 'Bosworth Jewel')

*c.*1600, 32 mm diameter
Watercolour on vellum stuck to playing card
The Royal Collection © 2004, Her Majesty Queen Elizabeth II
(RCIN 420013)

This portrait is inscribed in gold '.1536. Ætatis Suæ 46.' This and three
other miniatures by Hilliard that depict Henry VII, Jane Seymour and
Edward VI were originally contained in a single jewelled portrait box
(now lost) which, according to Charles I's curator Abraham van der
Doort, writing during the 1630s, had been made by Nicholas Hilliard
himself. The top lid of this jewel was enamelled with the image of the
1485 Battle of Bosworth Field. Hilliard clearly based the present
miniature on Hans Holbein II's image of Henry VIII, as used in the great
Tudor dynastic wall-painting in Whitehall Palace, subsequently destroyed
by fire in 1698.

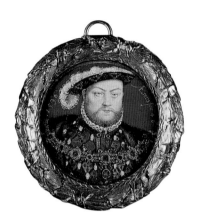

26 Nicholas Hilliard

Elizabeth I

*c.*1600 oval 62 x 47 mm
Watercolour on vellum stuck to playing card
Setting: gold enamelled in white, black, opaque yellow, pale green and pale blue,
translucent red, blue, green and yellow, set with table-cut diamonds and rubies.
V&A Images,
Victoria and Albert Museum, London
(P.4404–1857)

This late image of the queen depicts her in an idealised form as if still
a young girl, rather than a woman in her late sixties. Her loose, flowing
hair is a symbol of her virginity. The rich red curtain behind her is a
feature first seen in Hilliard's miniatures of the 1590s.

 The precious golden and bejewelled locket is a rare surviving example
of the luxurious containers in which portrait miniatures might originally
be presented. The openwork front is cast and chiselled with scrolling
tendrils, behind a star-centred pattern. The black-enamelled back bears a
French-inspired pattern including flowers and dolphins.

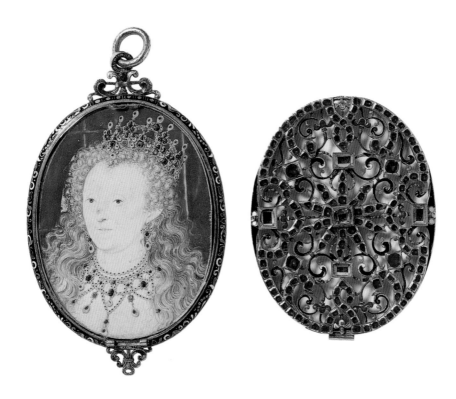

27 Nicholas Hilliard

Unknown Lady

1602, oval 59 x 44 mm
Watercolour on vellum stuck to pasteboard
V&A Images,
Victoria and Albert Museum, London
(P.26–1975)

Inscribed 'Videtur et Vere est [that is, 'it seems and truly is'] Ano Dni.
1602.', this work is thought, from the costume, to depict a middle-class
sitter rather than a court lady. The tall hat, in particular, signifies this
more modest status. The sitter wears a gold ring suspended on a black
cord from her bodice, to which are pinned a number of fresh flowers
including roses and, perhaps, carnations. A tiny blue flower is fixed to
her ruff.

This miniature is in an ivory box, possibly original, but now missing
its lid.

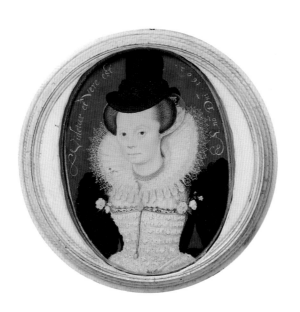

28 Nicholas Hilliard

James VI of Scotland and I of England

*c.*1605 oval 54 x 43
Watercolour on vellum stuck to pasteboard
V&A Images,
Victoria and Albert Museum, London
(P.3–1937)

This miniature is inscribed: 'IACOBVS.DEI.GRA[C]IA MAGNAE.
BRITANIAE.FRAN.ET.HIB[E..] REX.' At the accession of James VI
of Scotland as James I of England in 1603, Hilliard became the new
king's official limner. Payments for at least eight miniatures of James are
recorded, although clearly far more were in fact produced. This is a fine
example of the type Hilliard produced early in James I's reign. The king's
tall hat is pushed back to reveal his hair, giving him a surprisingly youth-
ful air. Hilliard also produced portrait medals for the king.

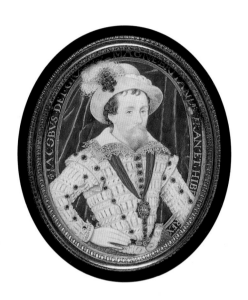

29 Nicholas Hilliard

Henry, Prince of Wales

1607, oval 61 x 51 mm
Watercolour on vellum stuck to pasteboard
The Royal Collection © 2004, Her Majesty Queen Elizabeth II
(RCIN 420642)

Inscribed 'Ano Dni 1607. Ætatis suæ 14.', this miniature depicts Prince Henry (1594–1612), heir to James I, who died in his late teens before he could succeed to the British throne.

Although doubts have recently been expressed about Hilliard's authorship of this work, Charles I's curator Abraham van der Doort wrote in the 1630s that it was 'done by the ould Hilliard', which the delicate handling and extensive use of burnished gold paint seem to confirm.

By this late period Hilliard's style may have been considered rather old-fashioned and, once he was old enough to choose for himself, Henry was to employ the much younger Isaac Oliver as his official portrait miniaturist.

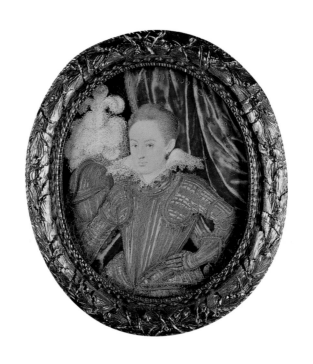

30 Nicholas Hilliard

Unknown Lady

Oval, 63 x 52 mm
Watercolour on vellum stuck to playing card, extended with further card
Private Collection

Views have differed as to the dating of this outstanding miniature which, if it is a late work by Hilliard, is unusually vigorous in execution.

The presentation of the sitter, shown in bed, is extremely unusual. Her ermine-lined cape and wired head-dress with its pearl-edged veil indicate that the sitter is of very high status. A richly ornamented blue bed-curtain is seen to the right. In a band at the top are the Latin words 'VIRTVTIS AMORE' in the form of lettered capitals used by Hilliard on his later miniatures (see, for instance, illustration 28). The text can be translated as 'with [or by] the love of virtue'.

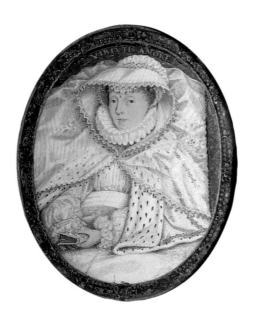

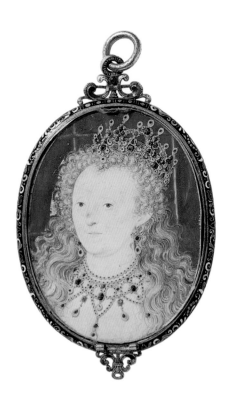

Bibliography

Auerbach, Erna, 'More Light on Nicholas Hilliard', *Burlington Magazine*, vol.91, 1949, pp.166–8

Auerbach, Erna, *Nicholas Hilliard*, London, 1961

Barclay, Craig and Syson, Luke, 'A Medal Die Rediscovered: A New Work by Nicholas Hilliard', in *The Medal*, no.22, spring 1993, pp.3-11

Blakiston, Noel, 'Nicholas Hilliard in France', *Gazette des Beaux-Arts*, 1958, pp.298–300

Colding, T[orben] H[olck], *Aspects of Miniature Painting*, Copenhagen, 1953

Coombs, Katherine, *The Portrait Miniature in England*, London, 1998

Edmond, Mary, 'Limners and Picturemakers', *Walpole Society* 1978–1980, vol.47, London, 1980, pp.60–242

Edmond, Mary, *Hilliard and Oliver*, London, 1983

Farquhar, Helen, 'Nicholas Hilliard, "Embosser of Medals of Gold"', *Numismatic Chronicle*, 4th series, 8, 1908, pp.324–56

Fumerton, Patricia, '"Secret" Arts: Elizabethan Miniatures and Sonnets', in *Representations*, no.15, 1986, pp.57–97

Hearn, Karen, ed., *Dynasties: Painting in Tudor and Jacobean England 1530–1630*, Tate Gallery, exhib. cat., London, 1995

Hearn, Karen, *Marcus Gheeraerts II: Elizabethan Artist*, London, 2002

Hilliard, Nicholas, 'A Treatise Concerning the Arte of Limning', MS Laing III, 174, Edinburgh University (see also Thornton and Cain 1981)

Jones, Ann Rosalind and Stallybrass, Peter, *Renaissance Clothing and the Materials of Memory*, Cambridge, 2000

Matthew, H.C.G. and Harrison, Brian, eds, *Oxford Dictionary of National Biography*, vol.27, Oxford, 2004 [entry on Nicholas Hilliard by Graham Reynolds, pp.217–24]

Murdoch, John, Murrell, Jim, Noon, Patrick J., and Strong, Roy, *The English Miniature*, New Haven and London, 1981

Murrell, Jim, *The Way Howe to Lymne*, London, 1983

Norgate, Edward, *Miniatura or the Art of Limning*, eds Muller, Jeffrey M. and Murrell, Jim, New Haven and London, 1997

Piper, David, 'The 1590 Lumley Inventory: Hilliard, Segar and the Earl of Essex' (parts I and II), *Burlington Magazine*, vol. 99, 1957, pp.224–31, 299–305

Pope-Hennessy, John, 'Nicholas Hilliard and Mannerist Art Theory', *Journal of the Warburg and Courtauld Institutes*, vol.6, 1943, pp.89–100

Pope-Hennessy, John, *A Lecture on Nicholas Hilliard*, London, 1949

Reynolds, Graham, 'Portraits by Nicholas Hilliard and his Assistants of King James I and his Family', *Walpole Society*, vol.34, 1952–4, pp.14–26

Reynolds, Graham, *Nicholas Hilliard and Isaac Oliver*, Victoria and Albert Museum, exhib. cat., London, 1971

Reynolds, Graham, *English Portrait Miniatures*, revised edition, Cambridge, 1988

Reynolds, Graham, *The 16th and 17th-century Miniatures in the Collection of her Majesty The Queen*, London, 1999 [particularly pp.65–78]

Strong, Roy, with contributions from V.J. Murrell, *Artists of the Tudor Court: The Portrait Miniature Rediscovered* 1520–1620, Victoria and Albert Museum, exhib. cat., London, 1983

Strong, Roy, *The English Renaissance Miniature*, London, 1983

Strong, Roy, 'The Leicester House Miniatures: Robert Sidney, 1st Earl of Leicester and his Circle', *Burlington Magazine*, vol. 127, October 1985, p.694 ff.

Thornton, R. K. R. and Cain, T. G. S., eds, *The Art of Limning*, Ashington and Manchester, 1981

Index

The roman numbers refer to text. References to illustrations are in bold.

93